The Primary Source Library of FAMOUS ARTISTS

MICHELANGELO BUONARROTI

Catherine Nichols

The Rosen Publishing Group's
PowerKids Press™
PRIMARY SOURCE

New York

For Peter

Published in 2006 by The Rosen Publishing Group, Inc.
29 East 21st Street, New York, NY 10010

First Edition

Editor: Kathy Kuhtz Campbell
Book Design: Emily Muschinske
Photo Researcher: Sherri Liberman

Photo Credits: Cover (background) © British Museum, London, UK/Bridgeman Art Library, (left) © Vatican Museums and Galleries, Vatican City, Italy/Bridgeman Art Library, (right) © Erich Lessing/Art Resource, NY; title page © British Museum, London, UK/Bridgeman Art Library; p.4 (left) © Scala/Art Resource, NY (right) © Bridgeman Art Library/Alinari; p. 6 The Art Archive/Doges Palace Venice/Dagli Orti; p. 8 © Alinari/Art Resource, NY; p. 10 (top) © Alinari Archives/CORBIS, (bottom) © Ted Spiegel/CORBIS; p. 12 (left) © British Museum, London, UK/Bridgeman Art Library, (right) © Ashmolean Museum, Oxford, UK/Bridgeman Art Library; p. 14 © Araldo de Luca/CORBIS; p. 16 © Arte & Immagini srl/CORBIS; p. 18 (top) © Alinari Archives/CORBIS, (bottom) © Bettmann/CORBIS; p. 20 (top) © Sistine Chapel, Vatican Palace, Vatican State/Art Resource, NY, (bottom) © Vatican Museums and Galleries, Vatican City, Italy/Bridgeman Art Library; p. 22 (left) © British Museum, London, UK/Bridgeman Art Library, (right) © Scala/Art Resource, NY; p. 24 (left) © Scala/Art Resource, NY, (right) © Galleria dell' Accademia, Florence, Italy/Bridgeman Art Library; p. 26 © Vatican Museums and Galleries, Vatican City, Italy/Bridgeman Art Library; p. 28 © Opera del Duomo, Florence, Italy/Bridgeman Art Library.

Library of Congress Cataloging-in-Publication Data

Nichols, Catherine.
Michelangelo Buonarroti / Catherine Nichols.— 1st ed.
 p. cm. — (The primary source library of famous artists)
Summary: Discusses the life and work of the Italian Renaissance painter and sculptor, Michelangelo Buonarroti.
Includes bibliographical references and index.
ISBN 1-4042-2763-6 (lib. bdg.)
1. Michelangelo Buonarroti, 1475–1564—Juvenile literature. 2. Artists—Italy—Biography—Juvenile literature. [1. Michelangelo Buonarroti, 1475–1564. 2. Artists.] I. Title. II. Series.
N6923.B9 N53 2005
709'.2—dc22

 2003016743

Manufactured in the United States of America

Contents

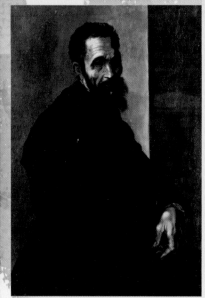

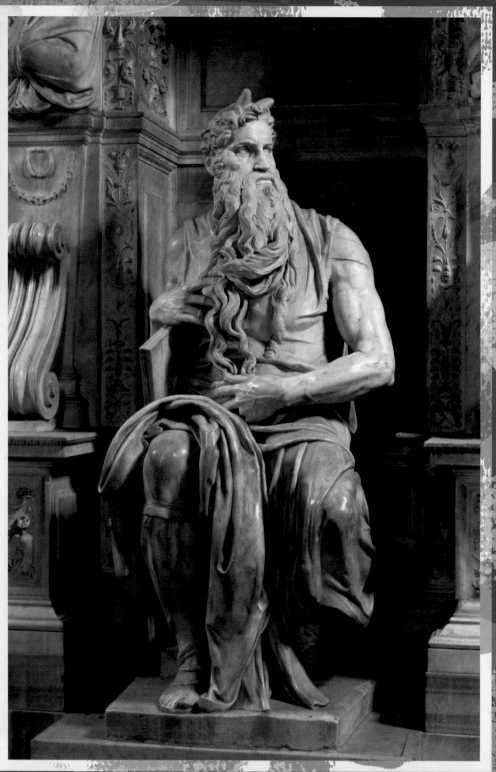

Above: Jacopino del Conte painted Michelangelo around 1535. Michelangelo had a flat, crooked nose. When he was a young student another student had hit him in the nose and broken it.

Right: Michelangelo carved Moses for a tomb, or grave memorial, between 1513 and 1516. It is one of his most famous sculptures because it looks so lifelike.

Artist of the Body

Throughout his long life, Michelangelo Buonarroti created **masterpieces** in **sculpture**, painting, and **architecture**. Unlike many great artists, Michelangelo was recognized as one of the most talented artists during his own lifetime. He was born in Italy in 1475 and died in 1564. Today he is considered one of the most important artists to have ever lived.

Michelangelo lived during the period called the **Renaissance**. Throughout Europe, people had taken a new interest in the art of ancient Greece and Rome. Michelangelo was captivated by **classical art**, especially by the way Greek and Roman artists had shown the human body. They had wanted the figures they painted and carved, or cut into shape, to look as real as possible. Michelangelo studied the human form to make his figures lifelike, too. His paintings and sculptures celebrate the beauty of the human body.

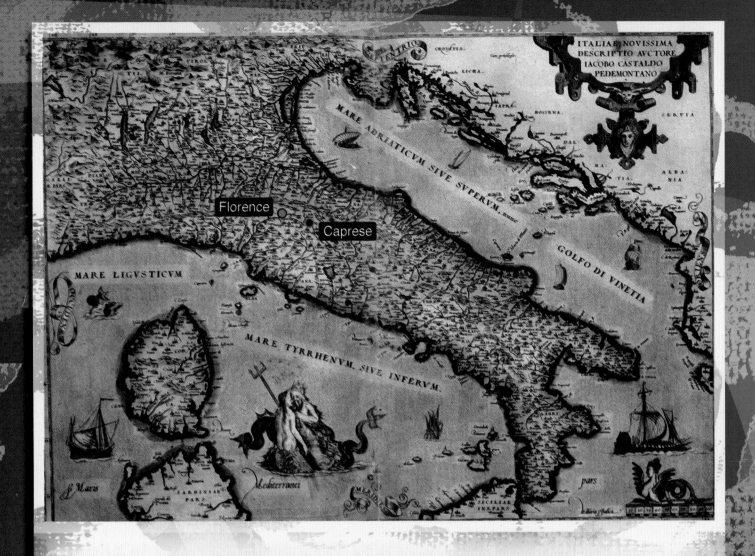

Florence

Caprese

This map from the sixteenth century shows the town of Caprese. Michelangelo di Lodovico di Lionardi di Buonarroti Simoni, or Michelangelo Buonarroti for short, was born in Caprese. Caprese lies in the mountains about 50 miles (80.5 km) east of Florence. When Michelangelo was a baby, his family moved to Florence.

Life with a Stonecutter

Michelangelo Buonarroti was born on March 6, 1475, in the village of Caprese, Italy. His father, Lodovico, worked as a court **magistrate** there. He held the job only for a short time. About one month after Michelangelo's birth, Lodovico and his family returned to their home in the city of Florence. At first Michelangelo did not live with his parents and older brother. Francesca, his mother, was not well and could not care for her two small children. Michelangelo was sent to live with a nurse. The nurse was married to a stonecutter. Later, while Michelangelo was still a baby, he returned to his parents' home.

Michelangelo's parents had three more baby boys before Francesca died when Michelangelo was six. He went to live with the stonecutter's family again. Much later, when he was a famous artist, he said that watching the stonecutter work had made him decide to become a sculptor. A sculptor is a person who makes or carves figures from clay, stone, wood, or other **material**.

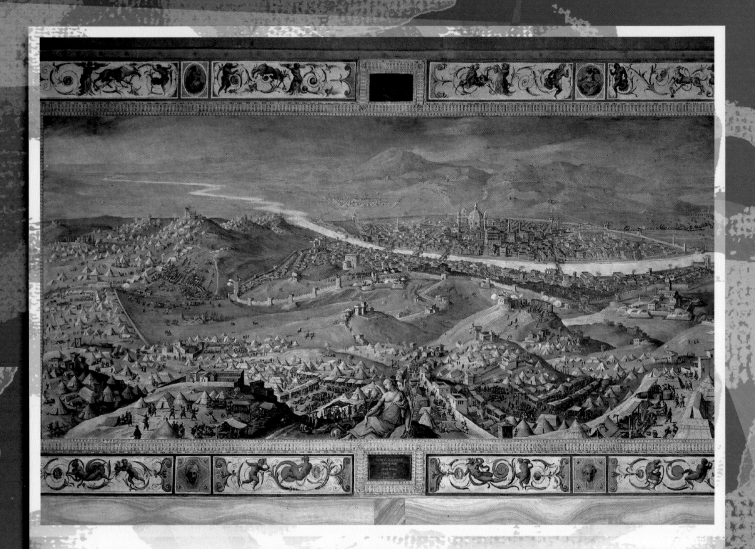

Giorgio Vasari painted this view of Florence between 1555 and 1571. Florence, or Firenze as it is called in Italian, was ruled by the rich and powerful Medici family for much of the 1400s and 1500s. Many members of the Medici family supported artists such as Domenico Ghirlandaio by paying them to create works of art for churches and palaces. Domenico Ghirlandaio was a well-known artist and the master of a large workshop in Florence when Michelangelo became an apprentice for him in 1488.

Starting Out

After four years of living with the stonecutter's family, Michelangelo returned to his father's house. He went to school and learned to read and write. He made friends with an older boy named Francesco Granacci. Francesco worked as an **apprentice** for Domenico Ghirlandaio, a well-known painter and sculptor. Michelangelo wanted to work in Ghirlandaio's workshop, too.

Lodovico believed that making art was useless. He believed that artists were not respected because they worked with their hands like common laborers. Michelangelo begged his father to let him study to be an artist. Finally, in 1488, his father gave in. As an assistant in Ghirlandaio's workshop, Michelangelo learned to draw and paint. He also studied the works of great Italian artists such as Masaccio and Giotto. With Ghirlandaio's other apprentices, Michelangelo received training in the art called **fresco** painting.

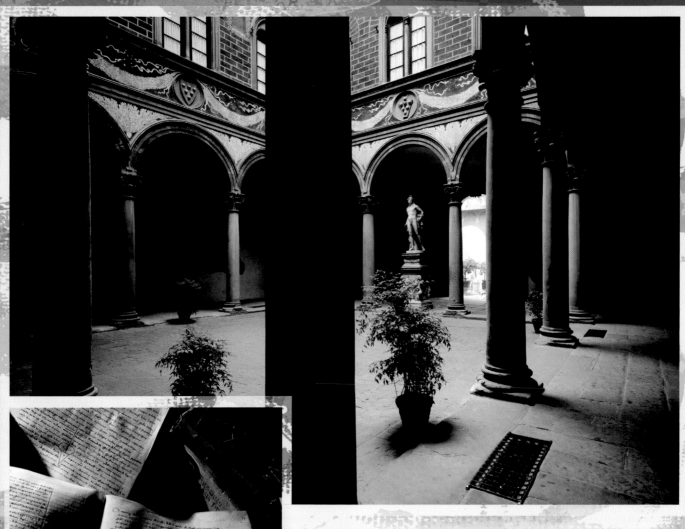

Top: Lorenzo de' Medici's grandfather had the Medici Palace built in the 1440s. This photograph shows the palace's courtyard. Michelangelo lived in the Medici Palace from 1489 to 1492.

Bottom: These coins, called florins, journals, and medals, belonged to the Medici bank in Florence. Lorenzo, who helped the young Michelangelo, is pictured in the large medal on the right.

A School for Artists

Lorenzo de' Medici was a wealthy and powerful man in Florence. He had a large collection of sculptures from ancient times. He displayed them in his garden near the **monastery** of San Marco. Lorenzo formed a school to teach young artists to create similar sculptures. He hired a teacher named Bertoldo di Giovanni. Ghirlandaio, a friend of Lorenzo's, suggested Francesco and Michelangelo as students.

At the school, Michelangelo learned to **cast** clay models in **bronze**. He preferred to work in **marble**, though. Lorenzo recognized Michelangelo's skill as a sculptor. He became like a father to the young man, and he invited Michelangelo to live in his palace. Lorenzo treated him as a family member and had him educated with his three sons.

Art Smarts

A relief is a sculpture that is made to be seen only from the front. Reliefs can be carved in low relief or in high relief. Sculptures carved in low relief are almost flat. Sculptures carved in high relief appear to come out from the stone quite a bit. Freestanding sculptures, called carvings in the round, are meant to be seen from all sides.

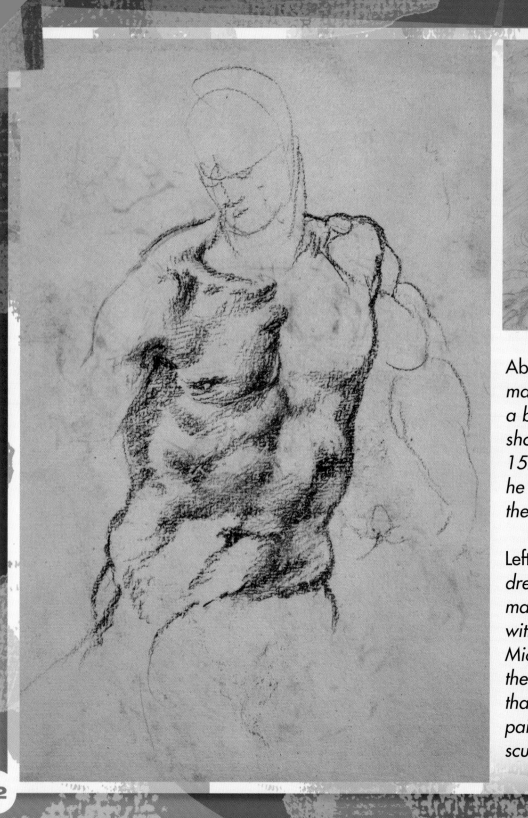

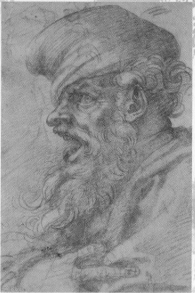

Above: Michelangelo made this drawing of a bearded man shouting around 1525. In his studies he learned about how the face worked.

Left: Michelangelo drew this study of a man's upper body with black chalk. Michelangelo studied the human form so that he could make his paintings and sculptures look lifelike.

Early Success and Studies

In 1492, when Michelangelo was 17, Lorenzo de' Medici died of an illness. Heartbroken, Michelangelo moved back to his father's house. Lorenzo's oldest son, Piero, became head of the Medici family. Piero did not have much work for Michelangelo. Michelangelo did not want to join another artist's workshop and he was too young to start his own. Instead he began to study the human body. To make his sculptures look more lifelike, he needed to know how the body worked. The prior, or head official, of the Santo Spirito church in Florence let Michelangelo study and draw at the monastery hospital.

In 1493, Michelangelo decided to work on a large sculpture, hoping to sell it. He carved *Hercules* from a huge block of marble. Hercules was a Greek hero. Michelangelo sold the sculpture, which was 8 feet (2.4 m) tall, and he was praised highly for it. The sculpture was lost during the early eighteenth century and its location is not known today.

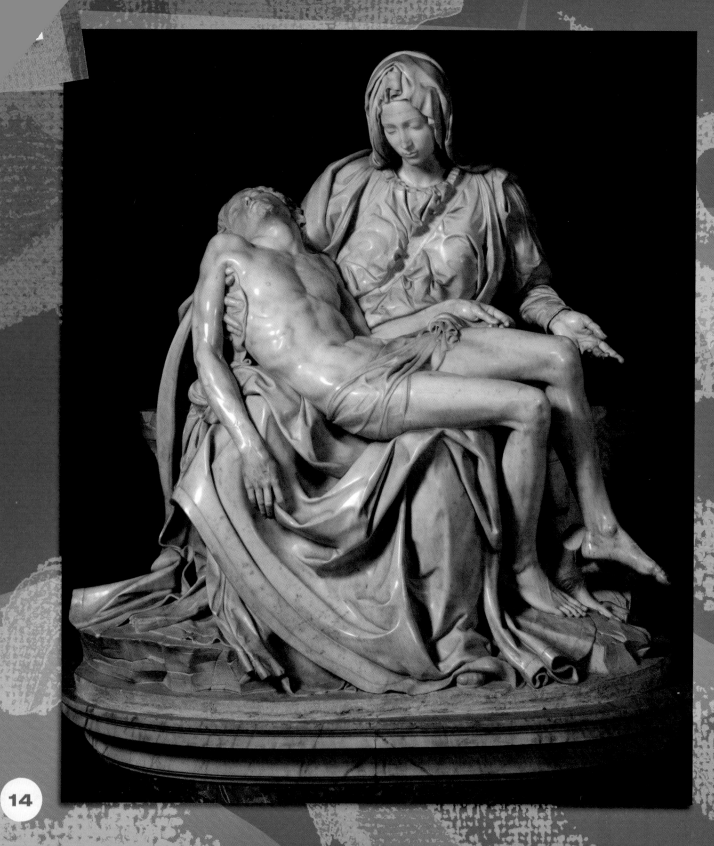

Michelangelo's *Pietà*

Piero de' Medici proved to be an unwise ruler, and the Florentines forced him from power in 1494. Because of his ties to the family, Michelangelo had to leave Florence. He went to Venice and then to Bologna looking for work. About one year later, he returned to Florence but he could not stay there. The preacher Savonarola, who was banned from the Roman Catholic faith, and his followers controlled Florence. They burned art and books that they thought went against their pure faith and teachings.

Michelangelo went to Rome. There, in 1498, he received an important job to make a sculpture for a tomb. The sculpture was a **pietà**. The word pietà means "pity" in Italian. The sculpture shows Mary holding the dead body of her son, Jesus Christ. It took Michelangelo two years to carve the *Pietà*, which is one of his finest works. At age 24, he was becoming known as a great sculptor.

Michelangelo's Pietà is shown here. When he heard a man saying that another sculptor had carved it, he decided to carve his name into Mary's sash, or the piece of cloth that is worn over the shoulder. It was the only time he signed one of his works.

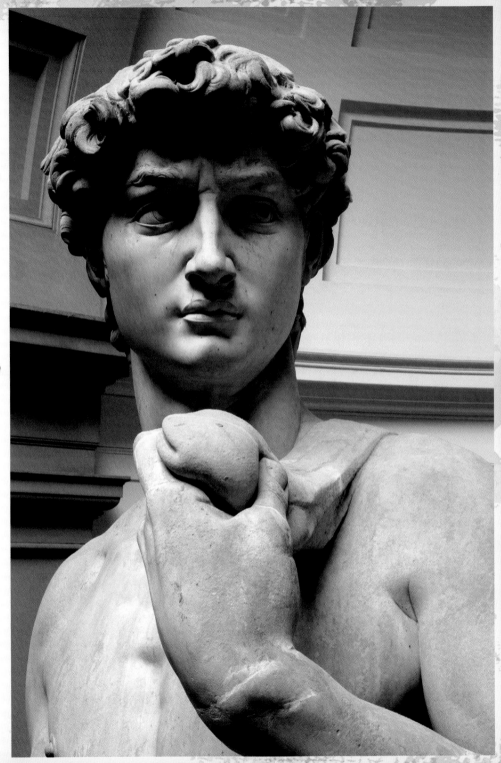

Michelangelo started to work on David, which was called the Giant, in 1501. It was originally planned to be placed in front of Florence Cathedral. When Michelangelo finished the sculpture in 1504, the government decided to put it somewhere else. The Giant was moved to the city square, called the Piazza della Signoria. It took 40 men five days to move David.

The Giant

Michelangelo returned to Florence in 1501. He had heard that the new government was looking for a sculptor to carve a large block of marble. The marble was 18 feet (5.5 m) tall. Years before, a sculptor had started to carve the marble but had done a poor job and had left it. Because of Michelangelo's success with the *Pietà*, the leaders of Florence gave him the job. Michelangelo, using tools such as special chisels and hammers, worked inside a shed so that he could be alone. He carved *David*, a sculpture of an Old Testament figure in the Bible. As a young man, David had killed Goliath, a giant, by taking Goliath down with his slingshot. Florentines saw themselves in David. They had lived through many wars in their city. Like David, they were small but were brave and strong. Michelangelo finished *David* in 1504. The sculpture, which Florentines called the Giant, was moved to the city's square. It established Michelangelo as a leading sculptor.

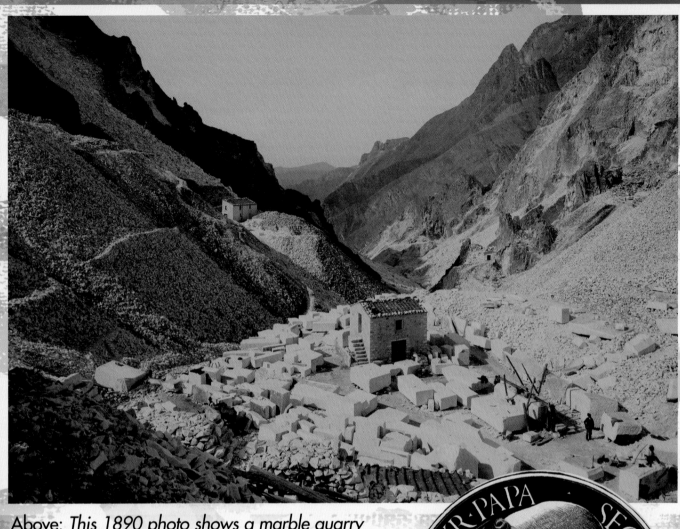

Above: *This 1890 photo shows a marble quarry near Carrara. Michelangelo spent about eight months working in these quarries to get the best white marble for Pope Julius II's tomb. He had used Carrara marble for the Pietà and David.*

Right: *Pope Julius II, shown here in a sixteenth-century print, was strong-headed and often argued with Michelangelo. He also was the artist's greatest supporter.*

In Trouble with the Pope

The head of the Catholic Church, Pope Julius II, called Michelangelo to Rome in 1505. Pope Julius II wanted Michelangelo to make his tomb, the place where the pope would be buried. Michelangelo went to the **quarries** of Carrara, Italy, for the finest marble. For eight months, he oversaw the cutting of the white marble. When he returned to Rome, Pope Julius II would not see him or pay him for the marble. The pope no longer wanted his tomb built, believing it would be bad luck if the tomb were built while he was still alive.

Michelangelo angrily left Rome and went to Florence. The pope ordered him to return so that he could make a sculpture of the pope. Michelangelo returned and made the sculpture. Then the pope asked him to do a bigger job.

Art Smarts

In 1506, a man digging in Rome found *Laocoön*, an ancient Greek sculpture. It shows the Trojan priest Laocoön and his sons being attacked by snakes. The priest went against the gods by warning the Trojans about the danger of bringing a wooden horse inside Troy. The energy Michelangelo saw in the sculpture affected his later works.

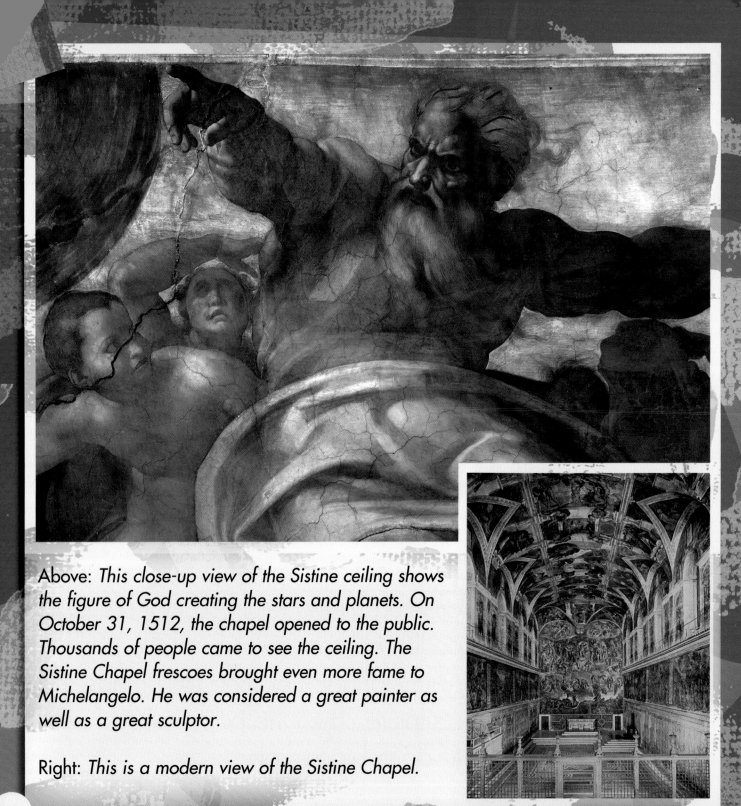

Above: *This close-up view of the Sistine ceiling shows the figure of God creating the stars and planets. On October 31, 1512, the chapel opened to the public. Thousands of people came to see the ceiling. The Sistine Chapel frescoes brought even more fame to Michelangelo. He was considered a great painter as well as a great sculptor.*

Right: *This is a modern view of the Sistine Chapel.*

The Sistine Chapel

Pope Julius II wanted Michelangelo to paint the 12 apostles, or the men who followed Jesus, on the ceiling of a church called the Sistine Chapel. Michelangelo did not want the job. He preferred sculpting.

Michelangelo was 33 years old when he began to paint the ceiling. Instead of painting the apostles, Michelangelo decided to paint Bible scenes. The method he used was called fresco. He did not have much practice with this style of painting, but he had learned it when he was an apprentice in Ghirlandaio's workshop. At first Michelangelo used apprentices, but he soon fired them. He painted standing up on **scaffolds** 50 feet (15 m) high, leaning backward, drops of paint falling in his face. It took him four years to complete the Sistine ceiling.

Art Smarts

"Fresco" is the Italian word for "fresh." In fresco painting, special paints are made and mixed with water or egg. The paint is applied to the surface of a wet wall or ceiling. In the 1500s, the surface was plaster that had lime added to it. The lime was a powder that caused the paint to bind with the surface. Fresco artists had to work quickly before the surface dried.

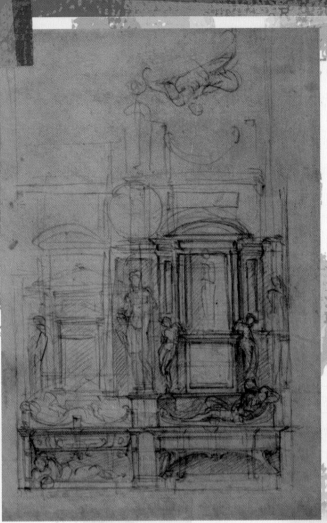

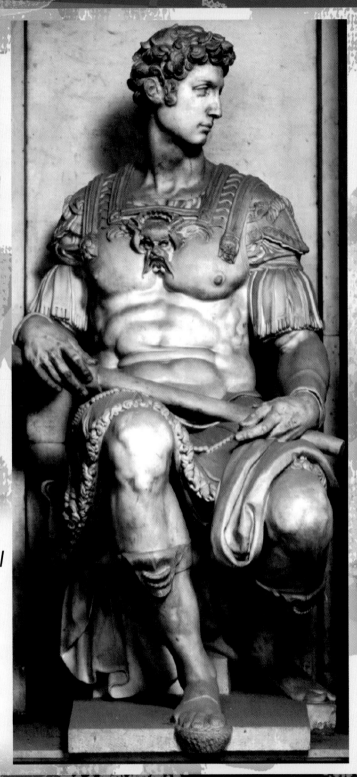

Above: Michelangelo made this drawing for the Medici tombs in the Medici Chapel in Florence's San Lorenzo church.

Right: He carved this sculpture of Giuliano de' Medici for the Medici tombs in San Lorenzo between 1526 and 1534. Giuliano, who was the Duke of Nemours, was Lorenzo de' Medici's son and Michelangelo's friend.

Working with Old Friends

When Pope Julius II died in 1513, his tomb was still unfinished. That same year, Michelangelo's boyhood friend Giovanni de' Medici became Pope Leo X. He let Michelangelo continue to work on the tomb. The tomb was meant to have 40 statues. Michelangelo carved two slave sculptures for it. The slaves stand for the arts, which people believed would be held back by the death of Julius II, their great supporter. From 1513 to 1516, Michelangelo carved most of a sculpture of Moses, a prophet from the Bible. A prophet is a religious leader who speaks as the voice of God.

By 1516, Michelangelo was in Florence working for the Medici family, who had returned to power. Pope Leo wanted him to rebuild San Lorenzo, a church in Florence. He hired Michelangelo to build the chapel and to make four sculptures for the tombs inside it. For 18 years Michelangelo worked on this and other projects. He completed only two sculptures for the tombs.

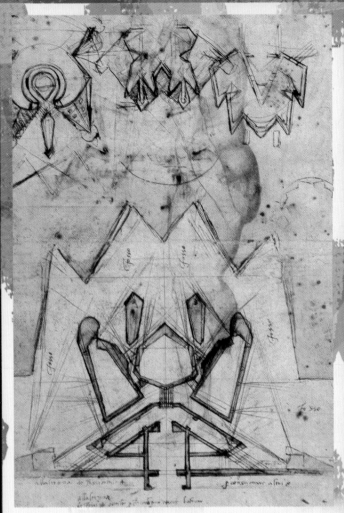

Above: *This drawing of a city wall in Florence was made by Michelangelo while he was a military engineer.*

Right: *Michelangelo planned to make this sculpture of a slave, also known as Atlas, for the tomb of Pope Julius II. It is thought that he started it in the 1520s. He never completed it.*

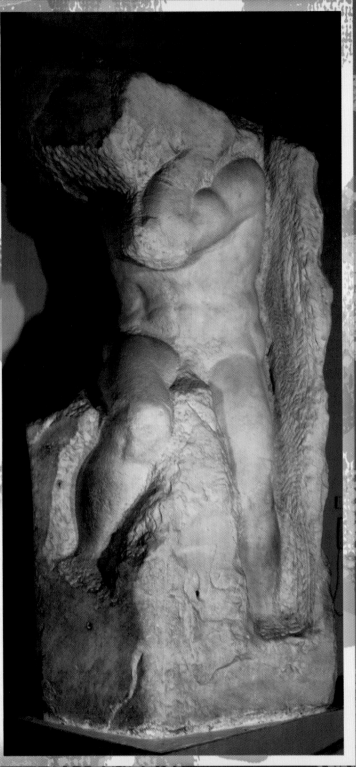

Michelangelo in Hiding

The Medici family had to leave Florence in 1527. The people took away the family's power and made Florence a **republic**. At that time Michelangelo was made an architect. He also worked as a military **engineer**. He oversaw repairs to the city's walls and made plans so that an attacking army could not get inside Florence. He worked on the tomb of Julius II, too. He began to carve five more slave statues, but he did not finish them.

By 1530, the Medici family were back in power. Michelangelo, who had helped the republic, feared for his life. The Medici family had ordered him killed. Michelangelo went into hiding for several months. The new pope, Clement VII, Lorenzo de' Medici's nephew, **pardoned** him on the condition that he return to work on the Medici tombs.

Art Smarts

Michelangelo believed that a sculptor should find the shape hidden inside a block of stone. To do this Michelangelo sculpted in an unusual way. Instead of working from all sides, as was usual, he carved from front to back. His unfinished *Slave*, also known as *Atlas*, shows this method of carving.

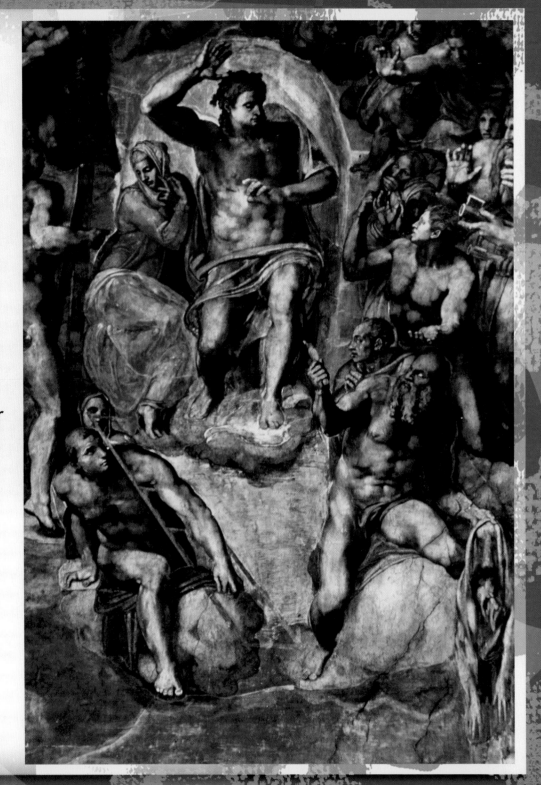

This view shows the figure of Christ in The Last Judgment. The face on the figure that is at the far right at the bottom is thought to be that of Michelangelo's. About 23 years after Michelangelo finished the fresco, one of his students, Daniele da Volterra, was hired to paint coverings on all the naked figures.

The Last Judgment

Michelangelo left Florence for good in 1534. He settled in Rome. A new pope, Paul III, wanted him to paint a fresco on the back wall of the Sistine Chapel. Michelangelo painted *The Last Judgment*, a Bible story that tells of people rising from the dead and being judged by Christ. In this fresco Michelangelo shows Christ in the center. At the bottom are people in Hell. At the top are people in heaven. He painted many of the figures undressed. He believed that people were made in the image of God, so the naked body was beautiful. This bothered Biagio da Cesena, one of the pope's officials. He did not think that a picture showing uncovered bodies should be in a chapel. Michelangelo did not have to change his painting, but to get back at Cesena, he painted Cesena as Minos, the king of hell.

The finished fresco was shown in 1541. It caused quite a stir. Pope Paul III was so overcome by what he saw that he fell to his knees and prayed.

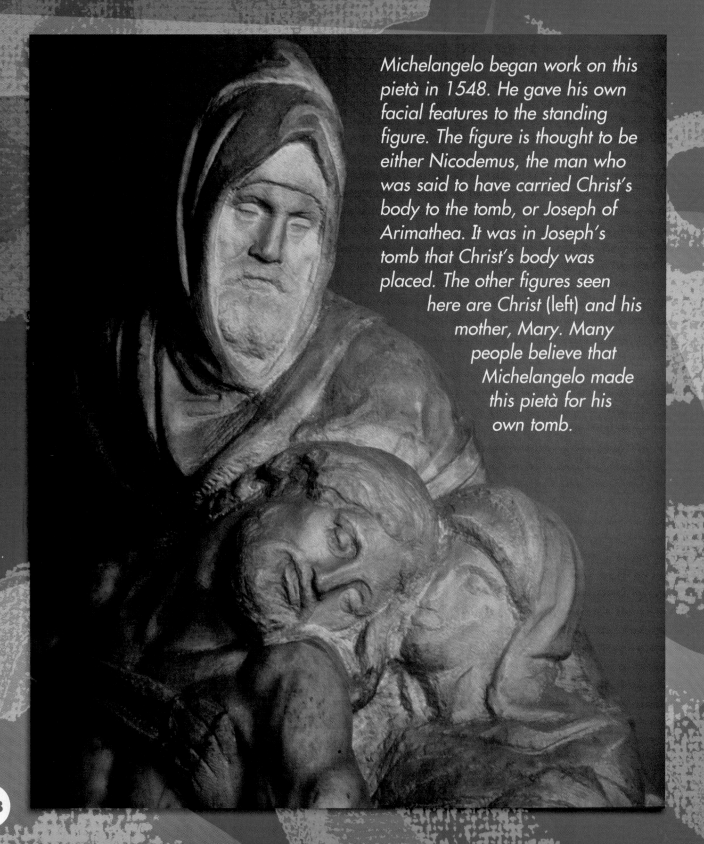

Michelangelo began work on this pietà in 1548. He gave his own facial features to the standing figure. The figure is thought to be either Nicodemus, the man who was said to have carried Christ's body to the tomb, or Joseph of Arimathea. It was in Joseph's tomb that Christ's body was placed. The other figures seen here are Christ (left) and his mother, Mary. Many people believe that Michelangelo made this pietà for his own tomb.

The Last Years

Michelangelo finished Pope Julius's tomb in 1545. He was 65 years old. Although he had been writing poetry since his student days, he took an interest in writing sonnets, which are a special kind of poem. He also worked as an architect. On January 1, 1547, he officially became the head architect for the rebuilding of St. Peter's church in Rome. He did not live to see the church finished, but he created the dome, which is a type of curved roof. He worked for free.

Art was what mattered to Michelangelo. He never married. Late in life he formed two strong friendships in Rome, one with Vittoria Colonna, a widow, and one with Tommaso Cavalieri, a nobleman. Michelangelo died on February 18, 1564. Many people believe he was the greatest artist who ever lived.

Art Smarts

Michelangelo wrote love poems, religious poems, and sonnets. Sonnets are poems that have 14 lines and a fixed pattern of rhymes. Before he died, Michelangelo burned some of his poetry, along with many of his drawings. In spite of this, many of his poems still existed. His grandnephew reworked the remaining poems and had them printed in 1623.

29

Timeline

1475	Michelangelo is born in Caprese, Italy, on March 6.
1488	He becomes an apprentice to the Florentine artist Domenico Ghirlandaio.
1489	Michelangelo goes to live in the Medici Palace.
1492	Lorenzo de' Medici dies.
1494–95	Michelangelo looks for work in Venice and Bologna.
1496–1501	He lives in Rome.
1498–1500	Michelangelo carves the *Pietà*.
1501	He returns to Florence.
1501–04	He carves *David*.
1508–12	Michelangelo paints the ceiling of the Sistine Chapel in Rome.
1513–16	He works on the tomb for Pope Julius II.
1516–34	He works for the Medici family.
1534	Michelangelo moves to Rome permanently.
1535–41	He paints *The Last Judgment* in the Sistine Chapel.
1545	He finishes the tomb of Pope Julius II.
1547	He is made the head architect of St. Peter's in Rome.
1564	Michelangelo dies in Rome on February 18.

Glossary

apprentice (uh-PREN-tis) A person who learns a trade by working for someone who is already trained.

architecture (AR-kih-tek-cher) The art of creating and making buildings.

bronze (BRONZ) A golden brown blend of copper and tin metals.

cast (KAST) To shape something by putting soft metal into a mold.

classical art (KLA-sih-kul ART) Greek or Roman art from ancient times.

engineer (en-jih-NEER) A master at planning and building engines, machines, roads, bridges, and canals.

fresco (FRES-koh) The method of making a painting on wet plaster, which is a mix of lime, sand, and water that hardens as it dries. It is also the painting.

magistrate (MA-jih-strayt) An official who makes sure that laws are obeyed.

marble (MAR-bul) A hard, smooth stone used for buildings and sculptures.

masterpieces (MAS-tur-pees-ez) Works done or made with wonderful skills.

material (muh-TEER-ee-ul) What something is made of.

monastery (MAH-nuh-ster-ee) A house where people who have taken vows of faith live and work.

pardoned (PAR-dund) To have excused someone who did something wrong.

pietà (pee-ay-TA) A painting or carving of the figure of Mary cradling the dead body of her son, Jesus Christ.

quarries (KWOR-eez) Large holes in the ground from which stones are taken.

Renaissance (REH-nuh-sons) The period in Europe that began in Italy in the fourteenth century and lasted into the seventeenth century, during which art and learning flourished.

republic (ree-PUB-lik) A form of government in which the authority belongs to the people.

scaffolds (SKA-fohldz) Stands raised above the ground for workers and building supplies.

sculpture (SKULP-cher) A figure that is carved or formed.

Index

Primary Sources

Cover. Left. *Libyan Sibyl*, detail of fresco painted by Michelangelo on the Sistine Chapel ceiling, around 1511, Vatican Museums and Galleries, Vatican City, Italy. **Right.** Detail of *Portrait of Michelangelo*, bronze bust by Daniele da Volterra, a student of Michelangelo's, made around 1564–66. **Page 4. Left.** *Portrait of Michelangelo*. Oil on canvas, painted by Jacopino del Conte around 1535. Casa Buonarroti, Florence, Italy. **Right.** *Moses*, sculpted in marble by Michelangelo, 1513–16, for Tomb of Pope Julius II, San Pietro in Vincoli, Rome. **Page 6.** Map of Italy and the Adriatic Sea, early sixteenth century, made by Ramusio and Grisellini. Doges Palace, Venice, Italy. **Page 8.** *The Siege of Florence*, painted by Giorgio Vasari between 1555 and 1571 for a wall in the Palazzo Vecchio, Florence, Italy. Vasari also wrote a book about many great Italian artists of the Renaissance, including Michelangelo with whom he studied and became a close friend. **Page 10. Top.** Medici Palace, in Florence, begun in 1444 by architect Michelozzo di Bartolommeo for Cosimo and Lorenzo de' Medici. **Bottom.** Medici Bank's Secret Journals with Medallions and Florins. Bronze medallions of Cosimo de' Medici and Lorenzo de' Medici, called Lorenzo the Magnificent, and golden florins minted by the Medici bank are on view at the Museo dell'Antica Casa Florentina in Florence. **Page 12. Left.** *Figure Study*. Black chalk, drawing by Michelangelo. British Museum, London, England. **Right.** *Head of a Bearded Man Shouting*. Red chalk on paper, drawn by Michelangelo around 1525. Ashmolean Museum, Oxford, England. **Page 14.** *Pietà*. Sculpted by Michelangelo from 1497 to 1500, for St. Peter's Basilica, Rome. **Page 16.** Detail of *David*. Sculpted by Michelangelo from 1501 to 1504, Academia delle Belle Arti, Florence. **Page 18. Top.** Marble blocks in quarry near Carrara. This photo was taken around 1890. **Bottom.** This sixteenth-century woodcut shows Pope Julius II and was made by Hugo da Carpi. **Page 20. Top.** Detail of God in the *Creation of the Stars and Planets* fresco by Michelangelo in 1511 for the Sistine Chapel ceiling, Vatican. **Bottom.** Interior view of the Sistine Chapel, before the restoration of the 1970s. Vatican Museums and Galleries, Vatican City, Italy. **Page 22. Left.** *Studies for the Medici Chapel* in the church of San Lorenzo, Florence, charcoal drawing by Michelangelo, around 1519–20. British Museum, London. **Right.** Giuliano de' Medici, sculpted for the Medici Chapel between 1526 and 1534. Giuliano, Duke of Nemours, died in 1516. Church of San Lorenzo, Florence. **Page 24. Left.** Fortification drawing. City wall drawn by Michelangelo in late 1520s. Casa Buonarroti, Florence. **Right.** *Atlas Slave*. Begun by Michelangelo in the 1520s but never completed, for the Tomb of Pope Julius II. **Page 26.** *The Last Judgment* fresco. Painted by Michelangelo, 1537–41. Sistine Chapel, Vatican Palace, Rome. **Page 28.** *Pietà*. Sculpted by Michelangelo between 1548 and 1555, but never completed. Opera del Duomo, Florence.

Web Sites

Due to the changing nature of Internet links, PowerKids Press has developed an online list of Web sites related to the subject of this book. This site is updated regularly. Please use this link to access the list:
www.powerkidslinks.com/psla/michelan/